N
43
.S
199

D1229592

THE ART
OF
DISPLAYING
ART

THE ART
OF
DISPLAYING
ART

by Lawrence B. Smith

THE CONSULTANT PRESS, LTD.
New York, New York

Published by:
THE CONSULTANT PRESS, LTD.
163 AMSTERDAM AVENUE
NEW YORK, NEW YORK 10023
(212) 838-8640

Portrait of Lawrence B. Smith by Lynn S. Smith
Book Design by Broadman Associates

Copyright © 1997
The Consultant Press, Ltd.
All Rights Reserved

ISBN 0-913069-53-1

Library of Congress Cataloging-in-Publication Data

Smith, Lawrence B., 1936-
 The art of displaying art / by Lawrence B. Smith.
 p. cm.
 Includes bibliographical references and index.
 ISBN 0-913069-53-1 (hc)
 1. Art--Exhibition techniques. I. Title.
N4395.S64 1996
707'.5--dc2O **96-27570**
 CIP

Printed and bound in the United States Of America

TABLE OF CONTENTS

The Art of Displaying Art

INTRODUCTION

Display, exhibition, visual presentation, and even visual merchandising are basically synonymous. They are governed by the same concepts, ideas and rules. Whether you are in a rural market place in Guatemala, in an automobile showroom in Germany, at a fashion show in New York, or in the Rodin Museum in Philadelphia, you are involved with visual presentation. Someone is trying to communicate with you in visual terms.

Although initially the differences between the peasant market stalls in Central America and the chrome and glass showrooms of a major European city may seem vast, upon closer examination, the similarities far exceed the differences. Whether a female form is striding down a temporary runway in a Givenchy gown or is carved from marble and perched on a pedestal, the similarities still outweigh the differences.

In each case, people are attempting to communicate with one another. The means of communication are remarkably similar and the messages are surprisingly alike — *Look at this!* — *Consider That!* — *Don't look there, look over here and buy this!* It all seems simple enough and maybe once it was, but in today's world with its incessant bombardment of visual stimuli coming at us from every direction all vying for our attention, it doesn't seem simple anymore. Our world becomes more visually active every day. It is computer screens at work and television screens at home. Now, thanks to M.T.V., we even watch our pop music. An assault, indeed.

Yet, if we explore and examine this field of visual presentation, we can learn to communicate visually and transmit our ideas clearly and succinctly. With few exceptions our message will probably be — Please consider this work of art. Or, we might say — *Please consider this work as it relates to its neighbors.*

For the purposes of this book, we will keep our messages simple and relatively benign. If you desire to delve into some of the subtle and

subconscious methods of communication and mind manipulation by gallery and museum settings, I recommend reading *The New Museology*, edited by Peter Vergo and published by Reaktion Books Ltd, London. Mr. Vergo's essay *The Reticent Object* is particularly fascinating in its examination of how the concept of exhibition may confer upon objects meanings quite different and far beyond the significance they possess as cultural artifacts. I also highly recommend Brian O'Doherty's brilliant investigation of the ideology of the gallery space in his book *Inside the White Cube*, published by Lapis Press, San Francisco, 1986. In this book you will learn how to present two and three dimensional artwork successfully in your gallery, office, and home, on a professional yet do-able level. You will learn how to make the viewing experience as comfortable and as pleasant as possible.

There are certainly great differences between the presentation of work in each of a gallery, office, and home but, again, let me stress that the similarities and commonalty far exceed these differences. I will, however, note and cover separately each area where the difference is significant.

Wellfleet, Massachusetts

Lawrence B. Smith

CHAPTER ONE
ARRANGING ART WORK ON YOUR WALLS

The successful arrangement of a group of framed works is one of the most challenging aspects of visual presentation. The challenge is so great because of the diversity among works of art in addition to the many elements of color and design that exist within a single given piece. There are compositional elements that may exist in a single work that can be so strong as to affect an entire wall. There are tensions that occur in art work or that we create by our placement of the work that can overpower the final arrangement. There is visual weight that needs to be recognized and dealt with. There are strong color statements that must be reckoned with. And, we've got to do all this while trying not to compromise the artist's intent. What an artist might be trying to say about a certain shade of red and our perception of it might be weakened if we place his work incorrectly. And we might stifle what someone was saying about visual tension or weight by our zealous placement of the work. All this and elaborate frames too. A daunting task, but not overwhelming.

Most of these extremes are the exceptions. For the most part, works of art are solidly composed so that the viewer's eye will be subtly nudged around inside the picture in a agreeable controlled manner. You are aided by the fact that part of the job of the frame is to keep the world out and the painting in. When you are finished, you decide to stop looking at a particular work and move on. We can help in determining where your eye and attention will next focus.

Very large paintings due to their extreme size are often so commanding that they are generally hung on a wall all by themselves. In galleries with high ceilings and wide walls they may share a wall with another work but, again, because of sheer size we tend to view these works one at a time. When we cease studying a work we move to the next.

The Art of Displaying Art

In a commercial gallery, we expect and readily accept the dominance of the art work. The dedicated purpose and the very *raison d'etre* of a gallery are to present art in a powerful way. This type of presentation, while impressive and dazzling to the viewer in the gallery, may be too intense for other circumstances. When we elect to visit a gallery or museum, we have decided to put all else aside for a while and consider only art. But in the office or work place, and most certainly the home, the presence of artwork should be less aggressive. We can integrate art into our lives in the work place or at home in a way that makes it seem more grounded and a part of our environment. We would quickly tire of even the most engaging works if they screamed at us every time we walked into the room.

I think you can easily recognize the difference in presentation between the temporary and the permanent exhibitions in a museum. The temporary exhibit will be a little more immediate, usually a higher density of work and often more written copy. The permanent exhibits are a little more peaceful. You get a *we're here for the long haul* feeling from them.

Similar modifications should be considered for work we put in the office and moreover for the artwork in the home. The artwork we might encounter in the office, whether its a couple of portraits of the founders or an extensive corporate collection, should subtly re-affirm the corporations stature and taste. It shouldn't scream — *Buy me!* or even say — *Look at me!* in a distracting manner. We are sharing space with this artwork many hours each day. It mustn't be visual intruder. The same restraint should apply in the home. We want to live in harmony with our artwork.

How do we accomplish this? How can a painting that shouted in a galley — one that spoke up in an exhibit hall — be made to behave in a manner consistent with our daily lives in our office or at home? We can't change the painting, but we can control everything else in relationship to it.

The Art of Displaying Art

- You can manipulate the light on the artwork.
- You can choose its exact location.
- You can re-paint the wall.
- You can place a plant next to it.
- You can make it far away or very accessible depending on how you arrange the room it is in.
- You can change the frame.

All these things and more affect your relationship to and hence your experience of a work of art.

Now, let's go back and discuss what is probably the most common and frequent challenge, the one mentioned earlier — what do you do with a group of assorted framed works. Whether you are hanging a half dozen small paintings over a couch or filling a gallery with drawings, photographs, posters, prints, hangings, and sculpture, you should start out with a sketch and a scale model of the space.

Now, I would be less than candid if I said I always made a model of every space I've hung work in. I haven't, but, I try to now. I've spent too many long hours dragging artwork from wall to wall and even from room to room, then doing a layout on the floor in front of each wall. Finally, I would struggle to dance around the laid out work while I hung the exhibit. It is time consuming and dangerous. Of course,

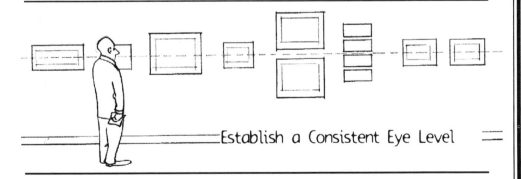

Establish a Consistent Eye Level

even after pre-planning with a scale model, there will be times when last minute changes and adjustments have to be made and you'll have

to lay it out on the floor, but you must keep this to an absolute minimum. It's not smart; it's risky and certainly unprofessional. Chapter Two - *Effective Use of a Model* tells you how to make and use a model.

When arranging framed work on a wall it is important to allow intervals of blank space now and then to break monotony and, more important, to give the viewer's eyes a little rest and his brain a chance to absorb what's being seen. Even if you are hanging a large series of works that are all the same size, find some variations in your arrangement. You can hang them all at the same level but, break up the spacing now and then.

I once saw a rather large gallery devoted to the exhibition of well over 100 magazine covers, each exactly the same size and all identically framed. The work had been hung at standard eye level with only

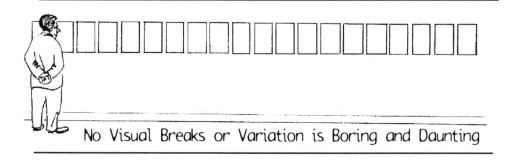

No Visual Breaks or Variation is Boring and Daunting

an inch or so separating each cover from the next without a visual break from beginning to end. The exhibit became one long, endless

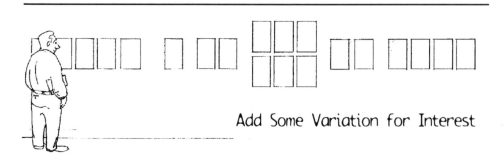

Add Some Variation for Interest

The Art of Displaying Art

stripe around all four sides of the room. It was deadly. The idea of looking at the exhibit with no respite in sight seemed so daunting that it became a task. People looked at a few covers and left.

The exhibit would have been much easier to look at and even fun if it had been hung with some intervals of space and some variations of placement. A couple of potted plants would have helped. Plants are magic in almost any exhibition. They bring a different dimension into an exhibition and provide some life to the space when it begins to bog down. A green plant can be a very welcome and refreshing break. However, I don't think the same applies to flowers, cut or otherwise. In the home they are wonderful but, in a gallery exhibit they look a little self-conscious and contrived.

Hanging a group of varied pieces calls upon your judgment in identifying some of those characteristics and elements found in artwork that I previously mentioned. Just like a painter tries gently to move your eye around his canvas, you should try to move the viewer's eye

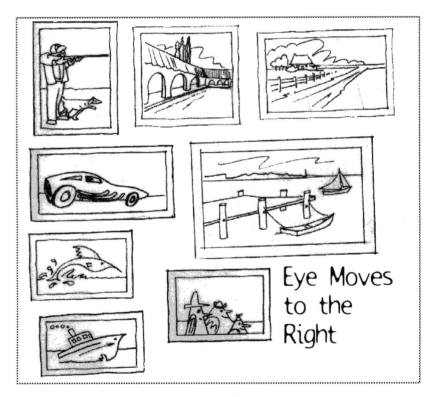

Eye Moves to the Right

from work to work in the same gentle manner. To accomplish this we can start by recognizing that we tend to begin looking at work from the left and often the upper left. This is probably because most of us in the western part of the world grew up approaching printed matter from this direction. That conditioning prevails when we are confronted with any large flat space.

One of the reasons some of the French impressionists were so intrigued and enchanted by Japanese prints was that, compositionally, they appeared so fresh and different, perhaps, because the artists who created them had other compositional habits engendered by a different printed page tradition. But we begin to look at a work, a group of works and even a whole gallery wall in the same manner — from the upper left.

If art work is of a substantial size and is hung side by side with its neighbor with only an occasional doubling up, we can expect your viewer to follow along from one to the next. But, if we are grouping work, we want to try and assist the viewers eye. We do this with a group of works on a wall the very same way an artist does it in a single painting by using color, mass, weight, and graphic images. People will follow the visual instruction of a symbol like this: ∧. And we will find these symbols, most often subtly concealed, in many works. Maybe the light areas against the dark lead our eye from top center to bottom right and out of the frame, ready to look at the next work. Most works will not be as obviously visually directional as my examples, but, it is important to try and identify any inherent directional messages in a work and use them accordingly.

In many cases, framed work is of a figurative nature and will, as such, contain some very simple and, sometimes, quite literal directional stimuli. Other figurative work and most non-objective works contain somewhat more concealed directional messages. The easiest way to learn to see these subtle directional indicators in a picture is to squint your eyes almost shut until the figurative content of the work is

The Art of Displaying Art

Viewer's Eye Will Move Up and Out of the Left Hand Corner of the Picture

Viewer's Eye Moves to the Left

blurred and only the color and vague shapes are distinguishable. Now you are seeing the basic composition and color massing without the pictorial story. This way you can read any directional messages and use them to help move your viewer's eye from piece to piece at a comfortable pace and rhythm.

As a child, I liked to stand on a street corner with a couple of my pals and stare intently at some pre-selected spot high on the building across the street. We would think it just hilarious when we noticed a passerby glance up to see

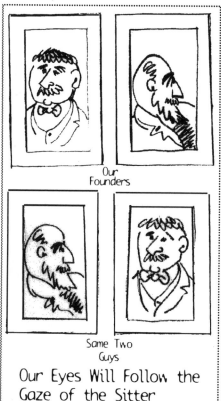

Our Founders

Same Two Guys

Our Eyes Will Follow the Gaze of the Sitter

what we were looking at. I've almost outgrown this prank. Now, more often I'm the victim who sneaks a peek at the spot where the others are staring. But, I did take away the obvious lesson that we do, indeed, look to see what others are looking at. Even if the looker is in a painting we will follow his gaze. When placing figurative works, we must be aware that this can happen. In portraiture, for example, we have a strong desire to follow the sitter's gaze. Most portraits look right back at us so there is no real problem but, if a pictured fellow is not returning

your attention because his interests are elsewhere or if he is in profile, you should try to anticipate your visitor's reaction and plan your space and placement accordingly.

Another very strong compositional element found in a great many figurative works is a horizon line. The horizon line of a painting is the same as the artist's eye level. That is one of the major rules of perspective. In most objective paintings, the horizon line, either observed or implied, will be in about the same place. In a group of traditional landscapes hanging side by side the horizon line will seem to run somewhat consistently from one to another. And, if the work is hung at you eye level, this line will reflect the actual horizon line outside.

Exceptions to this occur when an artist stands atop a sand dune to paint the surf fishermen down below or when a photographer lies on his back in the forest to snap the birds in the tree tops above him. These exceptions will cause a minor hiccup in the flow of a traditional group of works. Try to identify these peculiarities and give them some special attention. Use their unique composition to the advantage of the overall wall or place them off a little separately so that they don't have any unplanned effect on companion works.

These elements are not the only criteria to consider when placing work, and sometimes a few or all of them have to be ignored for other more compelling reasons. Yet, when you recognize the subtleties in addition to the more obvious elements of story, medium, size and shape and use them wisely, you will be able to give an arrangement of work a magical, subliminal cohesiveness and life that will set it above an arbitrary grouping of work.

For example, you might find that a pair of landscape paintings that initially appear to be rather placid, quiet, and tranquil, turn out to move your eye from one through the other and on out of the second picture too quickly. By studying the pictures you might find that there is a lot of horizontal energy and too few vertical elements within the work. On recognizing this, you might decide to hang them a little far-

ther apart so that the eye can catch its breath and slow down between them. Or maybe place them in a situation where the eye has nothing further to go to and will come back and look again. A potted plant might do the job or you might place the works near a wall so that the eye bounces back into the pictures.

After arranging a group of works, it is important to remember to give the viewer a break. We can accomplish this with carefully designated open spaces or, sometimes, plants or furniture. An observer needs time to consider and ponder what he has just seen. In addition, your viewers' eyes need a rest.

When doing a preliminary layout, use the squinting technique and make the appropriate directional and color notes on scale replicas of each of the pieces of work you are dealing with. Then move these miniatures around your model walls until you have a well laid out unit. A good eye level to work with is 5 feet 3 inches from the floor. This measurement applies in most gallery or exhibit situations.

There are a few important exceptions, however, and common sense should prevail. If you are hanging a show for children, you would want to lower the eye level accordingly. Parents can bend over a little but the kids can't stretch. If you are hanging art in the home or in an office situation you must consider that the work may be observed primarily by people who are sitting down. This, naturally, would call for a somewhat lower eye level.

A method of grouping and hanging that I find particularly

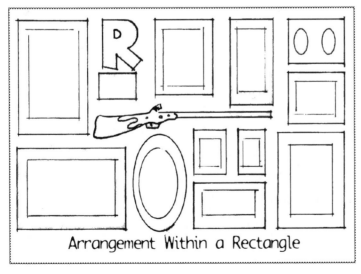

Arrangement Within a Rectangle

effective, especially in the home when one is often confronted with a large collection of bewilderingly diverse elements, is to create a simple shape using the various small pictures as its components. This popular layout technique brings a sense of order to an otherwise chaotic clutter of work. Use the outside edges of the outside pictures to form the shape. It can be somewhat formal as in a square or oblong. Or it can be more relaxed as in a circle or an oval.

You should try to create an agreeable design using the shape and general intrinsic impetus of each picture, plus being aware of the space between each work. This kind of arrangement works best in a home or an informal office setting. It is too informal for a gallery or museum layout or even a more formal office or board room. It is very effective when used with a large number of rather small works like family photos, small prints and drawings, and even some three dimensional objects. It is the sort of arrangement that might be just the ticket for over the sofa or in the doctor's waiting room. Sometimes this kind of arrangement can look too self-consciously contrived. If it begins to look as if the large shape on the wall is overpowering the artwork, you can defuse the impact of the shape by slightly breaking the outside edge. I think the top and bottom edges of the wall arrangement should remain even, but, the sides may be safely varied.

The space between pictures or between cases in an exhibit or even between objects in a vitrine has been christened by many as *negative* space. This is an unfortunate designation because it tends to make us think of empty space or the space around something as secondary or less important than the space that is occupied. From a design point of view, this just isn't true. The space around an object or shape is critical in the definition of that object or shape and tantamount to our experience of it. Just like Eskimos are popularly believed to have several words for snow there are cultures that have several words for this aforementioned space. And it is considered by their designers as a primary element in any design. I think that they are on the right track, so,

let's consider this volume around something not as negative space but as open space. The space between work that is hung as a group must be kept alive or the group cohesion will break down.

Let me explain what I mean by keeping the space alive. In a line drawing of a tree, or perhaps, a person's arm two adjacent lines indicate the space between them and define it as some kind of form. It is alive. And the space between the two lines is recognized by us as a tree trunk or as an arm. But, if these two lines are too far apart, the form dissolves and the two lines no longer describe the space between them. They become simply two lines with no real relationship to each other. The space between them is no longer defined as form of any kind and is dead. An artist's manipulation of these lines is one of the things that brings joy and wonder to drawing. In the same sense, the space between the works on your wall can be alive and actually contribute to your layout or it can be dead.

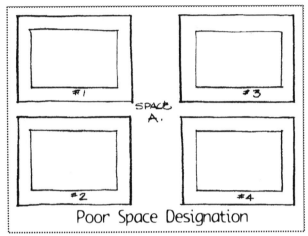

Poor Space Designation

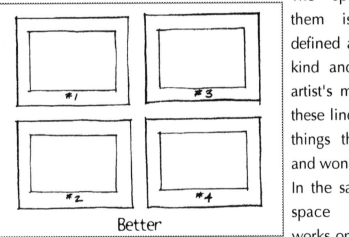

Better

As I write, I am looking at four engravings that hang over the desk in my study. They are not hung quite right. They look like this. The space between #1 and #2, and the space between #3 and #4 are both alive.

But, because the space between the two pairs [space A] is too wide it becomes *dead*. This creates a break in looking at the four works that I didn't intend. I'll fix it some day to look like this — If I want to present the four works as a set, then I must keep the open space between the works alive. I can accomplish this by moving the two pairs closer to each other. If I want to present the pieces as two separate pairs I've got to put more between them. Right now they just look wrong. It would be okay to hang the works as two pairs, except that they are all engravings by the same artist of similar scenes and they are all identically framed. Our common sense tells us that these all go together and we are confused by their inappropriate placement. If, for some reason, I want to indeed separate the two pairs, I think I would have to put them on different walls or at least have a lot of other work between the pairs. Our mind, in its endless and unrelenting search for relationships, will remember the first pair and try to put it together with the second.

These breaks created by open space are absolutely essential in creating a pace and rhythm on your wall. This is the primary reason why laying out space is just as important as laying out work.

The goal of arranging or designing a wall of work or a grouping of work on that wall is to create a unity among the pieces that has an impact of its own, while still maintaining the individual integrity of each piece. Through the careful arrangement of pieces, groups of work, and open space, all combined with the thoughtful placement of other elements like furniture, cases, plants, and maybe, sculpture, you can create an environment of positive art enjoyment.

Positive enjoyment leads to increased sales in your gallery and an enhanced aesthetic environment in your home or office.

YOUR EXHIBITION AND SITE SPECIFIC NOTES AND MEASUREMENTS

YOUR EXHIBITION AND SITE SPECIFIC NOTES AND MEASUREMENTS

CHAPTER TWO
EFFECTIVE USE OF A MODEL

Well utilized space is a key factor in the success of your presentation. In order to understand your space completely and know it intimately, you should make a scale model of it. Making a model is a vital step in the display process. A scale model is an irreplaceable tool in the creation of a serious exhibition. Even if you are dealing with one simple square room and hanging only five small drawings, I can not over emphasize the importance of a simple model. The only exception might be, if you are dealing with one wall and one wall only in a small room, then maybe a scale drawing (elevation) of that one wall might suffice. But, it is not that much harder to mount your elevation onto a piece of foam board or even a shirt cardboard and glue or tape it to a scale floor plan. A simple scale model requires us to think in three dimensional terms, and it helps us see, recognize, and deal with things that might otherwise not occur to us until much later in the process.

Make a scale model of each and every room or gallery or exhibition space you work with. Don't think that just because you are hanging a *flat* show consisting entirely of small paintings, drawings, or photographs that you can omit this important step. You will alleviate a myriad of problems at the end of your installation schedule by taking the time, in the beginning, to make a small model.

Your model should consist of elevations of each of your walls, drawn on or mounted to some kind of board that you will fit around a floor plan drawn in the same scale. Initially, just tape the walls together. You can glue them later, but, for now, you will want to be able to remove each one so that you can fasten model artwork to it. The model might be in any scale from 1/4 inch to the foot, up to 1 inch to the foot, depending on the size of your space. I have found it very helpful to

make my models from board that I have first covered with gridded paper or graph paper. Try to find some graph paper whose squares are in increments that will match up appropriately to an inch. 1/4 or 1/8th inch squares are good. I buy pads of paper that is gridded into one inch squares that are further divided into four squares to the inch. Its called 4 x 4 to the inch cross section gridded paper. Paper that is divided into five or ten squares to the inch is awkward for this particular use. Be sure to cover your boards with the graph paper before you cut them up into floors and walls. It will be a lot easier. I have had good results using spray glue to mount the paper, but the best way is to use a dry mount press, if one is available. Be sure to indicate the correct ceiling height in your model and don't forget to include doorways, windows, shelves, niches, cases, fire extinguishers, or anything else that effects the surface of your walls. When laying out your walls on gridded boards, remember to commence your wall measurement from a major grid line on the left and measure out to the right. Also, remember to leave enough overlap so that you have a flap to glue to later. You should try to leave just enough extra at the right side of each model wall to equal the actual thickness of your foam board or what-

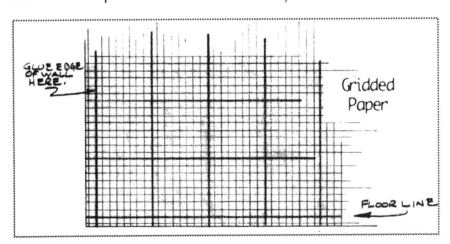

ever board you are using to make your model.

Start the next wall with a fresh major grid line. If you construct your model in this fashion, so that every wall starts at its left with a major

grid line, you will find it much easier to plan and organize each wall. In addition, you will find it very helpful to draw an eye level line across all your models' walls.

There are two different approaches to assembling your model. Both require that you mount a floor plan of your space onto a board. For the first method, you carefully cut out your floor plan along the outline of the room and then fasten the sides around the outside perimeter. In the second method, you leave the floor plan mounted on the board and, without cutting it out, you fasten the walls on top of the board along the appropriate floor lines. Choose the method that works for you and your space.

Remember to start the floor line of your wall with a major grid line too, just like the left edge, so that each layout will be easier to organize and simpler to calibrate. If you decide to cut out your floor plan and fasten the walls around the outside perimeter, be sure to add the thickness of the floor piece to the bottom edge of each model wall to allow for the overlap. Keep in mind that you want the wall grid to begin at the floor line with a major grid line.

It is very important, in model making as in cutting a mat, to make the edges of the cuts clean, straight, and even. To accomplish this, it is best to use a metal straight edge, to cut against and a very sharp mat knife or an X-ACTO knife with a #11 blade. A good technique is to cut foam board in two or more passes. After you line up the straight edge make a light cut that goes through the graph paper and through the paper surface of the board, but don't try to cut through the entire board. Then make one or two more passes to complete the cut. Try to hold your knife straight up and down so that the blade is always at a 90 degree angle to the board you are cutting. Foam board will dull a blade surprisingly quickly, and a dull blade will cause the foam board to pill and crumble. It may even tear the paper rather than cut it. So, as soon as you feel the blade begin to drag a little and start to slow down, it's getting dull and you should change it. It is not worth the risk

of ruining your model by trying to get one more cut from a dull blade. And, just like in the kitchen and the wood shop, a dull blade is more dangerous than a sharp one. Both mat knife blades and #11 X-ACTO blades are available in large quantity packages than greatly reduce their individual cost. A neat, clean cut edge not only looks better and more professional, it is much easier to glue.

When gluing a foam board use *Elmer's* or a similar type white glue. Avoid any glue that tends to dissolve or eat the foam. Don't use hot glue. It is too difficult to control in the tight confines of a small model and is also too thick. Run a light bead of glue along the entire length of the edge of the board, then, place it against the floor and its neighboring wall. Hold it in place till it dries (a few minutes) with tabs of drafting tape or a couple of drafting dots. Drafting tape has less tack or stickiness than ordinary masking tape and is less likely to tear the paper surface of the board when you remove it. If you don't have any drafting tape, you can reduce the stickiness of regular masking tape by patting its gooey side against a fabric swatch so that it picks up a little lint or fuzz and becomes less sticky. In any event, remove the tape just as soon as the glue is dry, because the longer the tape stays on the harder it is to remove. You can also pin the pieces together until the glue dries, but, of course, your model will end up with tiny holes in it. Sometimes you might want to leave a wall or two unglued so that they can be removed for easier access or a better viewing angle.

Now, on pieces of bristol board, or watercolor paper, or even 3" x 5" cards, draw the outline of each piece of artwork you intend to hang. Draw it in the same scale as your model. Don't forget to include the frame so that you have a representation of the actual size of the piece, not just the painting therein. If you have chosen a large enough scale to make it practical, you might want to indicate a few color notes on each little painting and include any extra strong compositional elements that would effect the final placement of the work.

The Art of Displaying Art

If you are exhibiting objects in cases, it is advisable to make models of these pieces too. Perhaps in a much larger scale. Each case, can be represented like you would construct a room. If you have the actual case at hand, you can skip the model step and try arranging full size cut out profiles of each piece right in the case itself. It's a lot quicker and safer to move foam board cutouts around in a case than the real objects. Don't forget to allow space for the labels, if you are going to use them.

When you have solved all the layout problems and your presentation is complete, carefully disassemble your model and save it to use again.

The use of a model works equally well with a small number of works and blockbuster exhibitions. The following retells how the legendary The Family of Man exhibition of photographs was arranged at the Museum of Modern Art.

> . . . the creators of *The Family of Man*, . . . relied heavily on such simple rules as avoiding overwhelming a few small pictures with many large ones. . . Steichen also used sketches of the display space, with scale drawings of [the] photographs, to attack these problems; the worst mistakes were thus confined to paper. Sketches of wall space were supplemented by a floor plan, which made possible the arrangement of photographs so that the viewer would come upon them in the proper order . . . In the final planning stage, the . . . staff found an architectural model a necessity; the design was too complicated to risk making all decisions from sketches and blueprints. *Caring for Photographs*, Time Life Books, New York, 1972.

YOUR EXHIBITION AND SITE SPECIFIC NOTES AND MEASUREMENTS

YOUR EXHIBITION AND SITE SPECIFIC NOTES AND MEASUREMENTS

CHAPTER THREE
HANDLING WORKS OF ART

There is little question that art objects of any kind are at their most vulnerable while being handled and moved. Our art pieces would be their safest and last their longest if kept absolutely still in total darkness with steady, controlled humidity and temperature levels. But those extremes are unreasonable. We want to look at our art and we want to share it with others. In exhibiting work, we do indeed put it at some risk. But this risk can be kept at a minimum, if we adhere to some guide lines and follow a few tried and true art handling procedures.

Before you begin to handle any objects of art, the entire area, gallery, office, or living room must be declared a non-smoking area for, at least, the installation period, and better, for the duration of the exhibit. Next, remove dangling jewelry that could possibly snag the art and hanging jewelry that could swing into the art.

Wash your hands frequently! Your hands must always be as clean as possible and often that isn't enough! Optimally, when handling art you should wear lintless white cotton gloves. Gloves manufactured

Beware of
Dangling Jewelry

for just this purpose are available from TALAS (see RESOURCES) and at most camera stores.

In general, since we know that handling art puts it at its greatest risk, we should handle it as little as possible. This may seem to be an overstatement of the obvious but bear in mind that, if you move a piece to point *A* and later move it to point *B*, the risk has doubled. If you can decide on point *B* in the first place, perhaps with the aid of a scale

model (see CHAPTER TWO) or a Polaroid Print, you can materially reduce the risk of damage.

It is also important to know exactly where you are going to place a piece before you pick it up. This is for two reasons. One, it saves aimless wandering and the possibility of putting it down in the very same spot where you picked it up. And, two, while you have a piece of work in your hands, your attention must be focused on it and not on trying to find a place for it.

Handle only one piece at a time and use both hands. If you think you might need help with a work, you do. Wait for someone to lend a hand. When possible, use a vehicle of some sort to move work. Use an art cart or gallery cart for small items and a dolly for large pieces. A padded side truck should be used for large paintings.

Don't leave works of art on the floor. Never keep art work on the same table as hanging hardware, tools, or lighting equipment.

When handling paintings, never touch the surface or the back. Handle a painting by its frame only and use both hands. Find spots on the frame that are secure. Try to hold a picture by the top third of the frame so that you can be certain the center of gravity is well below your hand hold. Sometimes, you will grasp the hanging wire snugly near the 'D' rings. Carry the work as close to the floor as practical. A small painting can be carried with one hand on the side and the other underneath. Let good judgment and common sense prevail.

Hold Unframed Paintings By Outside and Inside Edges of the Stretchers

When moving unframed framed oil paintings, resist the impulse to grab the piece by the top stretcher. Hold the picture from the rear by the two side stretchers. Don't let your fingers touch the front surface. Hold

The Art of Displaying Art

Hold Sides Like a Pack of Cigarettes

the two sides the way early television pitchmen held a pack of cigarettes. Don't lean a picture against anything except a wall or a panel that is bigger than the picture. The slightest dent in either side of a picture surface can cause serious damage that sometimes isn't immediately noticeable. Paintings should always be carried and stored vertically. When a painting is resting on the floor, it should be on pads or padded strips.

Avoid stacking paintings against one another and against a wall. When you absolutely must stack them, be sure to put the largest one first and then protect it with a large piece of light board like Upson board, Homosote, or foam board. The board should be slightly larger in each dimension than the painting it protects. Lean the next largest painting against the board; then protect it, in turn, with a piece of board and so on. Limit stacks to 5 or 6 pictures at the most.

If the pictures you are working with are in gilded frames or have frames with a soft matte finish, clean hands are not good enough, and you must wear white cotton gloves. Perspiration and natural oils from your hands can damage the surface of those frames.

When working with small objects like small sculpture or decorative arts works, handle only one piece at a time. Don't handle anything unnecessarily. Move each piece by sliding one hand underneath while steadying the piece with the other. Whenever possible, the piece should be placed in a padded tray and moved on an art cart.

Don't lift sculpture by a protruding part, like a head or an arm. Even if a decorative art piece has handles, you will be well advised to support the piece with you hand underneath. Handles have often been repaired and may not be as secure as they appear. When moving more than one piece in a tray or cart, see that the pieces are generously padded and that nothing protrudes over the sides of the tray or box.

When working with extremely small and delicate items, like jewelry, ivories, or small enameled pieces, it is sometimes a good idea to first wrap the piece in tissue before using any kind of cotton or padding. Cotton can be ever so slightly abrasive and can also snag and catch on delicate and/or intricate parts.

As a general rule, clean hands are not enough protection against the potential damage caused by perspiration and natural oils in the skin, and the wearing of white cotton art-handling gloves is recommended. This applies not only to small, delicate items but to large stone or metal sculpture as well.

In some instances, the object may be slippery, as in the case of highly glazed ceramics, or the work may have a surface that may snag the threads of a glove. In these situations, the risk of dropping the item may be greater than the risk of exposure to oils or perspiration, and clean, bare hands are preferable to gloves. As an alternative, you may want to try what are called curator's gloves, also available from TALAS. These are white cotton gloves with tiny vinyl dots on the palms and fingers. The dots create a non-slip surface. When in doubt, your common sense and good judgment should prevail.

When moving valuable furniture, avoid sliding or skidding it across the floor. Always lift and carry the piece. Don't lift a chair by its arms or even its back. Lift a chair by grasping it under the seat. Tables and most other furniture should be carried by solid structural members of their framework. You will usually need help.

You may be able to move a piece by yourself in an emergency, by placing it on a blanket or a shower curtain and dragging it for a short distance by grabbing the edge of the blanket or curtain and letting the piece glide along. Consider this method as a last resort and for only a very limited distance. Whenever possible, furniture should be moved on hand trucks or dollies.

If the furniture is upholstered, be sure to cover the fabric carefully with a clean sheet or some other protection. When a piece of furni-

The Art of Displaying Art

ture has moving parts like drawers, doors, or drop leaves, tie the piece securely with rope or furniture movers' straps before moving it. Use padding where the rope touches the wood. Remove glass or marble tops. Pad and wrap them carefully. Both glass and marble, like paintings, should travel vertically on their edges. Both can break under their own weight when transported flat. Don't stack furniture when moving it.

Strive to keep furniture pieces in their intended positions. A delicate chair can support a remarkable amount of weight in a traditional manner. A portly grandfather on a wooden chair may be able to hold his rotund grandson on his lap with no problem. But, should he lean the chair back on its two rear legs, it's likely he and child would soon be on top of a pile of expensive kindling. A theater set designer explained to me that furniture used on a raked or slanted stage, has a very short life because the stress on a piece is at an angle for which the furniture was not designed. The examples are to remind us to keep all the feet on the floor as intended.

Most importantly, remember to focus exclusively on the object that you are handling. When it is late at night and you are moving the last piece of work to its final spot, make an extra effort to keep your concentration on the task at hand. A high percentage of accidental damage can be avoided if we use good judgment and keep our minds on what we are doing.

YOUR EXHIBITION AND SITE SPECIFIC NOTES AND MEASUREMENTS

YOUR EXHIBITION AND SITE SPECIFIC NOTES AND MEASUREMENTS

CHAPTER FOUR
SAFE AND EFFICIENT HANGING HARDWARE

One of the most frequently performed and essential elements in the presentation of art work is the hanging of pictures on a wall. It is crucial that this be accomplished in a secure manner so that pictures remain where intended and don't fall off the wall. Art falling off the wall not only damages the work but presents a real danger to persons in your gallery, home, and office. A standard piece of advice given to new residents of California is to avoid hanging work over the head of beds and on walls abutting desks. Earthquakes do not respect even the most secure hanging methods.

Secure fastening requires care and a an understanding of how it works. There are three areas or steps to consider. Number one is installing a hook or some other kind of hanging device securely on or into the wall. Number two is assuring that there is some kind of dependable hardware or frame configuration on the back of the art work. and, number three is a method or device to join these two elements securely together.

Basically, it may seem we're talking about a nail, a couple of screw eyes, and a length of wire, and, in an over simplified sense, we are. But, each of these elements has to be carefully selected to insure that you make the correct choice of hardware for the job, i.e. that it is of substantial enough size and strength for the particular work of art, its frame, and the wall.

First, let's examine the device we will attach into the wall. There are several variables to consider and there are different types of hardware suitable for various conditions. The two major factors are the weight of the artwork to be hung and the actual construction of the supporting wall. Most pictures are light enough so that the picture hooks

available at the local hardware store are adequate to support them. Most pre-packaged picture hooks list a weight capacity on the pack. They are available in a variety of sizes and strengths and you may select a size a little stronger that called for to be on the safe side. Some hooks come with a slender tempered steel nail. These nails are quite strong in spite of their thinness and are less likely than a regular nail to damage and/or weaken the supporting wall on installation or removal.

Two Types of Picture Hooks

Picture Hooks with Two Nails

There are two or three different styles of simple picture hooks, but they are basically the same in that they offer a more secure and safer hanging notch than that which is created by simply driving a nail into the wall. Some hooks are designed to use two and even three tempered steel nails to increase the holding power. These hook

Picture Hooks with Three Nails

devices offer much more security than the single nail would. Moreover, you would need a much larger nail to do the same job if using a single nail. In addition, the hook is configured in such a way that, when correctly installed, it directs the nail into the wall at its most efficient weight bearing angle.

When you are hanging something quite heavy like a large painting in a heavy frame, a mirror, or, perhaps, a relief, the simple picture hooks will not be adequate and a heavy duty hook must be employed. In this case, it should be attached to the wall with screws or bolts, depending upon the construction of the wall. In any event, the hooks

must be securely and dependably fastened to the wall. If not correctly fastened, the best hanging hardware will be useless.

If you are hanging work on a temporary wall or wall panel made of Homosote, you will be able to hang only relatively light work. To hang heavier work you will need a wall of gypsum board or dry wall or a Homosote panel backed up by plywood. To hang extremely heavy work, even the dry wall needs a plywood backing unless you can contrive to secure the hooks for the heavy things through the dry wall into a stud. Most artwork is not so heavy that it needs this special treatment.

There are several different types of fasteners that can be utilized that will permit you to hang quite substantial works on a hollow or studded

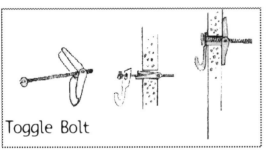

Toggle Bolt

wall. And there are many others for solid walls. For hollow walls, toggle bolts or expansion bolts, often called mollys, will do the job nicely. For a solid wall of plaster over brick or block, for example, a lead or steel expansion anchor will work.

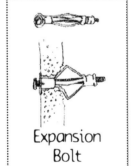

Expansion
Bolt

Molding
Hook

If you are uncertain what to use, describe your particular wall to one of the knowledgeable clerks at your hardware store. They are a good source of information.

In some cases, a picture molding runs around the room just below the ceiling and everything is hung from this molding by utilizing a special picture rod. Sometimes work hangs on long wires or monofilament fish line attached to special molding hooks or S hooks clipped onto the molding. The wire or line can be fastened to the picture in the traditional manner and hung over one or two hooks so that you might be able to adjust the picture's

position easily while standing on the floor. If you are using a molding clip that is fashioned from a flat piece of metal, beware of sharp edges that might catch and abrade the wire or line as it runs back and forth across it.

Some people prefer the following methods of leveling or positioning when using a picture molding. One method calls for fastening two separate equal lengths of line to two separate hooks and do the final adjustments at the back of the picture while standing on the floor. Or, try this method. Fasten one long piece of wire or line first to a molding clip or S hook. Next, run it through the eyes or D rings on the back of the picture and tie it off to the second ring or hook. Careful measuring of the line will give you the correct height for the work. Fasten the clips or hooks in place onto the molding. The piece can be leveled by simply tilting it to and fro on the long continuous line. When using this method, some installers like to take an extra turn of wire around one eye or ring on the picture to create more friction or bind on the line, so that once the picture is leveled it is more likely to stay that way.

The hardware on the back of the picture is the second important area of consideration in the hanging of work. There are several devices to choose from. Turn around half a dozen various works of art in frames and you are likely to find as many different methods of attaching the work to the wall. I've seen stove wire fastened to screw eyes, cotton string between two carpet tacks, lamp cord knotted around wood screws, and all kinds of staples, bent nails and cup hooks haphazardly embedded into the frame or stretchers and string, light chain, and even a shoe lace

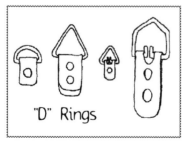

"D" Rings

for hanging. All this ingenious creativity not withstanding, the only correct piece of hardware to fasten to the back of a picture frame is a D ring. D rings are available in various sizes and are, by far, the best device to fasten to the frame of your artwork.

The Art of Displaying Art

Try to avoid using screw eyes. They are all wrong for the hanging of work. When they are screwed straight into the back of the frame, they tend to force the piece to hang away from the wall too much. When work is stacked or stored, eyes in the work can damage other work. In addition, the dynamics of forces involved, when artwork is hung, adjusted, or is just hanging there, are such that screw eyes tend to work loose and let go. If you install the eyes into the edge of the frame in such a manner that the eyes are parallel to the picture surface they will be less of a hazard to other work and won't hold the picture away from the wall, but they won't hold it on the wall for long either. Lastly, the quality of screw eyes that have recently been manufactured, especially in those little pre-packaged sets, is substandard. The threads are cut so poorly that the eye can barely hold itself in a piece of wood, let alone be secure enough to support a valuable work of art. In addition, the metal is often brittle. If I haven't been convincing and you insist on using them, do it as seldom as possible and take extra care. Try to avoid the pre-packed eyes and buy yours individually or in bulk from a full line hardware store. Choose relatively large ones. Examine each one carefully and discard the ones that don't have clean sharp threads. Pre-drilling a small pilot hole will help, but, remember, they are just not the correct device for the job!

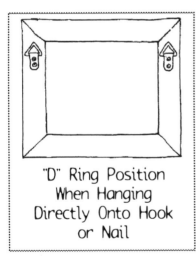

"D" Ring Position
When Hanging
Directly Onto Hook
or Nail

For a first rate installation, use D rings. For most framed works two rings should be screwed to the back of the frame, one on each side, about one quarter to one third of the way down from the top of the frame. Measure carefully. Hang the work directly onto two picture hooks or nails that are securely affixed to the wall. This is the safest and most secure way to hang a piece of work. When employing this method, you must measure very, very, carefully

because there is no margin for adjustment. Most extruded metal frames have a slot on the back into which a D ring is fitted. These can be easily adjusted up or down to fine tune the final position on the wall. Once you hang work in this manner it will remain securely in place. Because it is so tedious and time consuming, this method is best for a permanent installation.

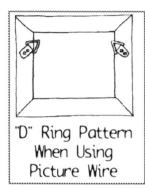

"D" Ring Pattern When Using Picture Wire

A more convenient method of hanging work leads us to the third element to consider in the procedure, which is the utilization of braided picture wire in combination with our D rings. Basically, picture wire is run between the two rings and the wire is then placed over two picture hanging hooks or two nails secured in the wall. The D rings are still screwed into the back of the frame about one quarter to one third of the way down from the top, but they are angled in such a position as to allow wire to run from the top of one ring across the wall hangers to the top of the second ring. This slight adjustment to the position of the D ring puts the stress on it at the correct angle.

The braided picture wire that we use is composed of several strands of very fine wire that are joined together in various manners for strength and manageability. This is another area where quality varies widely. Some wires contain fourteen or more strands of fine wire that are carefully braided together to form a nice, strong, dependable product. But, others may be composed of only six strands and are not really braided but simply twisted together. Wire fashioned in this manner frays on the ends and tends to separate in the middle. The fraying and separation makes it vulnerable to wear and subsequent failure. Examine your wire very carefully and look for steel wire with as many strands as possible, that are braided not just twisted together. Picture wire, like the hangers or D rings, is available in a wide variety of sizes and the hanging capacity is generally noted.

The Art of Displaying Art

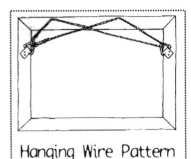

Hanging Wire Pattern

You should weigh the piece of artwork and then choose a braided steel wire that is rated at least twice as strong as needed. To be on the safe side, select a wire that is rated even higher.

I am not convinced that simply twisting the wire around itself is safe enough and I like to knot the wire around the ring and then twist the end around the main strand so that there is no loose end to contact the back of the work. The most fastidious among us will even tape over this final twist as an added precaution. On very small and very light pieces a single run of braided wire is sufficient with each end securely fastened to its D ring. On larger work a double run is safer. My favorite hanging method is shown. The wire is placed over the hanger hooks in the manner indicated. Pictures installed in this manner seem a little more resistant to jarring and accidental shifting.

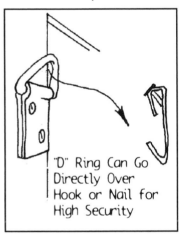

"D" Ring Can Go Directly Over Hook or Nail for High Security

The use of picture wire is appropriate for work that is not too wide or too heavy. If a piece is 30" or 36" wide, it is beginning to approach a size that may be too heavy to be safely supported by wire. If the frame of a work is very thin and fragile, the dynamics of hanging it by wire may distort or even break the frame. There is no exact rule governing when to use wire and when you must use only D rings hung directly to the hooks

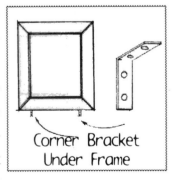

Corner Bracket Under Frame

on the wall. I think common sense and a feel for the particular situation is the most reliable indicator. But, I think it is safe to assume that, if you are wondering if a certain piece is too heavy, it probably is.

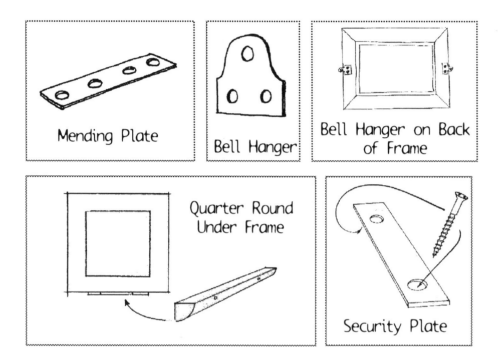

For very heavy pieces, a little additional support can be installed directly beneath the frame to take some of the weight, off the hanging hardware and relieve some of the internal stress on the piece. Small corner brackets may be mounted to the wall so that they support some of the work's weight, or a length of quarter round or other simple molding can be fastened to the wall in an inconspicuous manner.

Additional stabilization may be achieved through the use of mending plates or bell shaped hangers, fastened to the back of the piece before it is hung and then secured to the wall after the piece is placed and levelled. This process will keep a piece exactly where you put it. It shouldn't move at all despite the vibrations of traffic and normal every day activity.

The bell hangers or plates can be fastened to your wall with special security screws that will make them quite resistant to pilferage or tampering. The slots or drive holes in the screw heads may be filled with framer's wax, smoothed over, and then a daub of wall paint will ren-

der them almost invisible. You can stabilize a piece of wandering art-work, in a quick fix temporary procedure by placing little tabs of double-faced foam tape on the back of both lower corners of the frame. This won't deter pilferage but it will make the piece quite stable. Foam tape has a remarkably high resistance to shearing action. Things taped with a little bit of double faced foam tape won't slide from side to side.

Each and every element of the hanging process must be executed correctly using the proper hardware of an adequate size. Or, like the proverbial chain with a weak link, there will be a failure. It is false economy to try to stint in these areas.

YOUR EXHIBITION AND SITE SPECIFIC NOTES AND MEASUREMENTS

YOUR EXHIBITION AND SITE SPECIFIC NOTES AND MEASUREMENTS

CHAPTER FIVE
LIGHTING WORKS OF ART

Without a doubt, the single most important element in any form of visual presentation is light. In any other area you can cut corners or fudge a little, but, if there is no light, there is no presentation. Yet, light remains largely misunderstood and frequently neglected. Lighting is both an art and a science. As such, it is not as easy to pick up and assimilate on the job as other skills may be. A careless or uninformed use of light is, at best, in derogation of the aesthetics of the exhibit and, at worst, dangerous and destructive.

Two of the factors contributing to the general lack of quality in lighting are its high cost and its complexity. Even in many professional gallery situations, where there may be budget enough to allow for sufficient lighting, we find inept applications.

Somewhere, between the uniform often too bright light, that makes many contemporary galleries resemble warehouses, and spotlights tightly focused on the art, lies a happy medium. Spot lights make each portrait look like Hamlet's ghost and landscapes look like little ornate picture windows. The happy medium results in carefully illuminated areas with compelling highlights on appropriate pieces. That is lighting design.

Even if you are fortunate enough to have the services a professional lighting designer available, it is important that you understand basic techniques. You may desire to do some of your own lighting and you should be able to understand and exchange ideas with the professional.

When you are working by yourself in your home or are tending to a collection in the corporate sector, you can follow a few rules and, with very limited means and some cleverness, give your artwork a high quality and professionally presented appearance.

The greatest single danger to artwork is its exposure to ultraviolet light. Although we cannot see the ultraviolet rays, they are present in just about all the forms of light we encounter. These are the rays that help our food grow and give us our suntans, but they also bleach the lining of our curtains, fade the arms of upholstered chairs that are too close to the window, and result in a dark spot on the faded wallpaper when we take down or move a picture or a mirror.

Ultraviolet rays are a major component of sunlight. That is the major reason we try to eradicate or at least carefully control sunlight in any exhibition situation, where vulnerable artwork is involved. But, controlling sunlight is only half the battle, because artificial light poses similar problems.

There are basically two types of artificial light, fluorescent and incandescent. Both contain, in varying degrees, elements that are harmful to artwork. Yet, we must have light if we are going to have any kind of presentation. So, we have to understand how to use it in ways that will be satisfying and beautiful without running any unnecessary risks to our artwork. If you understand a little about how to create and control artificial light and recognize how the eye will react to it, you should have no trouble presenting even the most delicate watercolor or a most vulnerable tapestry in a very gratifying manner.

Fluorescent light can be very harmful to art objects. It contains a high percentage of ultraviolet rays. It is quite difficult to control and, in most cases, should not be used to light paintings, drawings, fabrics, works on paper, books, or manuscripts. If you have no options, be aware of its potential hazards and slide ultraviolet ("U.V.") filters over the tubes and, when possible, use U.V. filtering plastic to glaze cases or flat work.

Let us now focus our attention on incandescent light. Incandescent is a term that refers to the lamps that produce light, when electricity is pumped along a wire (filament) contained in an airtight glass bulb. In lighting parlance, we have the terms *fixtures* or *instruments* and

lamps. Lamps are what we know around the house as bulbs, and, the device we put the lamps into are known as fixtures or instruments.

The incandescent method of producing light has its own set of formidable drawbacks. The most significant of these is the considerable heat that is produced as a by-product of incandescent light. About 90% of the energy consumed by an incandescent light goes into producing heat. This heat definitely has its uses in other applications. Down at the diner, it keeps our fries warm until the burger is ready, but it is a disadvantage in an exhibition situation.

The intensity or amount of light on a surface can be measured. It is measured in foot-candles. A foot-candle is the approximate amount of light produced by a candle on a surface one foot square at a distance of one foot away. There are special light meters available that measure in these increments.

Damage caused by the exposure of material to light is cumulative. That means that prolonged exposure to a low level of harmful light can be just as destructive as a relatively short exposure to a high intensity light, such as direct sun light or a spot light.

Uneven exposure to light can result in the burning in of a *hot spot* on a piece of work. Countless paintings have been ruined by painting lights that fasten to the top of a picture frame. The light bulb is positioned so close to the painting that, not only do the U.V. rays bleach out the top of the work, but the infra-red heat rays damage the paint, canvas, and frame.

The heat damage is compounded as the light is turned on and off each day and the picture suffers daily expansion and contraction in an uneven and, hence, a distorting pattern. Clearly, to be in control of the illumination of our work is of the utmost importance.

In the routine of our daily life, we experience a range of useful artificial light that runs from about 5 foot-candles to around 200. When we are groping for a seat in a darkened movie theater, we are at the bottom of that range at maybe 5 foot-candle, and the light in a hospi-

tal operating room or the light a watch repairman uses will read out in the 200 range. We are most comfortable and perform most of our daily interior tasks in a range between 50 and 100 foot-candle.

Curators and conservators have strict guide lines covering how much light they will permit projected on certain objects. Textiles, for example, particularly antique pieces, are especially vulnerable to light and conservators recommend no more than 5 foot-candle of light on them even for exhibition! The list of objects that are particularly sensitive to light also includes prints, drawings, photographs, watercolors, manuscripts, books, and stamps. This, of course, explains why so many exhibitions seem so dark. They are intended to be dark!

But, there are ways to work within these guide lines and still present our work in an exciting manner. Understanding how our eye works and how we react to light will help.

Moving from a brightly lit area to a dark one too quickly is unpleasant and can even be hazardous. As you leave a movie theater after a Saturday matinee, you experience discomfort from the bright light, coming out of a dark space into strong sunlight.

For some reason, our eyes adapt more quickly from dark to light than vice versa. Our eyes accomplish this adaptation by opening or closing the iris to let in more light in dim conditions or less light in bright conditions. This adjustment, called dilation, happens automatically but, it does take a little time, and the older we get, the more time it takes.

The Broadway show *Cabaret* took advantage of this time lag in our adaptation to extreme light changes, by flashing exceedingly bright lights right into the eyes of the audience for a moment or two just before a black out on stage. Thus, we are effectively temporarily blinded and prevented from seeing scene changes taking place right before our dazzled eyes. These are extreme examples, but they serve to demonstrate what happens when we experience two different light levels in quick succession.

The Art of Displaying Art

A similar reaction and subsequent reduction of vision will occur when one is confronted with two substantially different light levels in the same view or field of vision. In addition to the time required to make this light adjustment, it takes a little energy too, and, if we ask the eye to do it frequently in a short period of time, our eyes begin to get tired.

Thus, our aim in lighting an exhibit must be to create light levels that achieve some excitement and drama without risking any sudden reduction of the viewer's vision, even temporarily, all the while being mindful of the conservation considerations regarding the objects.

Many objects that we might want to exhibit are not effected by exposure to ultra violet rays. Stone, glass, jewelry, metal, and most ceramics are quite happy in increased light. Still, we have to consider the other end of the spectrum, where we find the infrared or heat rays that can do their own kind of damage. The experts have determined that 30 to 40 foot-candles is a prudent limit of light on most objects for exhibition.

Fluorescent light is particularly strong at the ultraviolet end of the spectrum. That's why we use fluorescent tubes as grow lights, when we don't have enough sunlight. Fluorescent light comes from a tube and the light comes evenly from along the entire length of the tube. Even if the tube is bent into a bulb-like shape or into a circle, which city dwellers have christened the *landlord's halo* because of its ubiquitous appearances in apartment hallways, the light still comes out along the entire tube.

Therefore, since the light doesn't come from a single point, there are no hard edged shadows cast by objects lighted by it. This is a distinct disadvantage if you want to show an object's texture or the brushwork of an oil painting. Most sculpture is ill-served by fluorescent light because the surface texture and any undercuts that define a piece of sculpture are lost, or at least, softened by it.

Because fluorescent light produces such a high output of wave lengths at the ultraviolet end of the spectrum its color rendition leans toward the blue or cool end of things — a great light for sorting socks but not the best light for art work. There has been remarkable progress in improving the quality of fluorescent light recently and some designers like to take advantage of the low actual temperature of fluorescent light. They use it in certain situations, often as a general illumination, while using a small incandescent spot as an accent light. This seems like an acceptable plan for certain objects; but, textiles, watercolors, photographs, and the natural dyes, found in so many collectable artifacts, remain so highly vulnerable to the ultraviolet content of light that I feel it is prudent to keep fluorescent lighting to an absolute minimum. It should always be filtered and carefully controlled and monitored. There are meters that can detect and read the amount of ultraviolet rays in a light source, but they are expensive and most often used only by museum and lighting professionals.

The ideal lighting set up for art and collectibles is a track system in the ceiling. The tracks should run around the perimeter of the room set back or in from the wall at a distance of about one quarter of the wall height. For example, if your ceiling is ten feet high, the track should be about two and a half feet away from the wall. A twelve foot ceiling would require three feet and so forth. A very large room or a gallery would be well served by additional tracks, placed nearer the center of the room, so that fixtures may be installed to light any sculpture, free standing pieces or cases.

If you anticipate using a temporary kiosk or removable panels, you will require tracks to light them efficiently. In the ideal situation, the lights or instruments will each have built-in dimmers so that the intensity of each lamp can be adjusted and set at the time of installation to a predetermined appropriate light level.

Tracks installed in an intricate pattern plus a wide, diverse inventory of lighting instruments is ideal and, of course, expensive. In most

cases the reality of the situation falls short of such an ideal. But, let's try to do the best with what we have at hand and within our budgetary restraints.

In lighting flat work , such as paintings, drawings or textiles that are hanging on the wall, we want to cover the entire surface of the work with a bath of light that is even, has no hot spots, falls within the foot-candle range that has been determined as acceptable, and, lastly, doesn't reflect any light into the viewer's eyes.

In addition, if the work is glazed, you must be aware that the viewer doesn't want to see himself reflected in the glass. The so called non-reflective glass or acrylic is presently not a viable solution to the problem of reflection because many people find it difficult to see the art that has been covered with it. New technologies promise to alleviate the inherent problems of non-reflective glass.

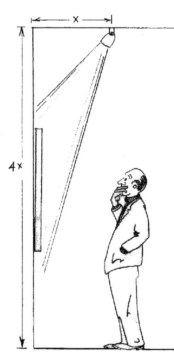

A 1 to 4 Ratio Will Offer a Nice Wash of Light Without Hot Spots or Annoying Reflections

If you are able to keep the light source away from the wall at a distance of about a quarter of the ceiling height, you should be able to wash the work in an even light with no hot spots and no troublesome reflections. Finally, here is a chance to use that mantra you learned in high school about the angle of refection equaling the angle of incidence. If the light comes down from the ceiling at a steep enough angle, it will bounce or reflect off the work at the same angle and fall harmlessly onto the floor.

When lighting larger pieces, if you have enough instruments instead of one light focused on the work, try shining one light from the left on to the right side of the picture and another from the right onto the left side. You would be able to get even

more light on to a picture by moving the light source farther away from it, but, in doing so, you will run the risk of having your taller viewers see the shadow of their own heads against the art work. This is not a sign of six more weeks of winter; it is simply a sign of clumsy lighting.

Conversely, if you move the light source too close to the wall, you run the risk of casting light onto the viewer himself, which increases the chances of the viewer seeing his own image reflected in a show case or a glazed picture surface. This is a veiling reflection and is a major annoyance in lighting art work. The 1 to 4 ratio of distance to wall height seems to be the best general rule to follow in attempting to solve these problems. Try to position and aim light sources so that the light cast does not bounce off light colored walls and floors and reflect into the viewer's eyes.

The more sophisticated lighting systems will have instruments that can be focused, shuttered, and dimmed. If you have or can afford to install this kind of set-up, you will be able to create and control your light output and make it do just what you want and need it to do. But, if you have only a few spot lights, a couple of clip lights, or, maybe, just a fixture in your living room ceiling, you can still, with minimum expense, create a lighting environment that will be safe for your art work and have a professional appearance.

Home centers and some hardware stores carry inexpensive so called track light systems that can easily be attached to the ceiling to replace a simple light fixture. These quasi- track systems, while hardly top of the line, still allow you a little flexibility in aiming a light toward the art that you want to present. A simple household dimmer can be installed fairly easily in place of a conventional wall switch. The dimmer, of course, gives you control over the intensity of the light produced.

There are a several other ways to reduce the intensity of the light that falls on your artwork if dimmers are not a viable possibility. One way is to reduce the wattage by chaging bulbs. Another is to screen the

bulb with pieces of wire cloth cut to fit your light. There are materials available from specialty suppliers who will cut the cloth to your specifications.

As an alternative, you can go to the hardware store and get a few feet of regular metal window screen. You can cut it into small pieces that can be fastened in front of your light source. This is a method that is very popular in low budget light control. Be sure to get metal screening; plastic or any kind of fabric screening won't do the job and may present a fire hazard.

There is also a metal foil available from theatrical or movie lighting suppliers. This foil comes in black or white and can be formed around lights to act as a shutter to keep errant light from wandering where you don't want it. Using any type of screening tends to create additional heat so the area may require more cooling and/or ventilation.

When the content of a presentation dictates very low light levels on objects and walls, it is very important to keep the general illumination of the room to a very subdued level so that there are not great contrasts in a person's area of vision. It is the contrast between two light levels in one's view that creates glare, difficulty in seeing, and eye fatigue. In an area of subdued light, our eyes will adjust and we will be able to see everything quite comfortably, as long as we are not interrupted by jolts of bright light. The contrast between the lowest light levels and the highest levels that one experiences in the same view should be kept around a ratio that does not exceed one to three. This is conservative yet it still allows you to create some interesting and compelling situations. Always remember, the ambiance you are creating is not about how cleverly you can manipulate light — it is about the presentation of art work.

The lighting of dimensional pieces requires a little special attention. A large part of the beauty of sculpture is in its volume and dimensionality. When we light a piece of sculpture, we have to be sure we are enhancing the piece and not doing it a disservice. Bland, even

lighting that casts no shadows will flatten the piece and erase some of its beauty. The form and volume of dimensional work is evidenced by light and shadow. And we must preserve this play of light and shadow on the surface of a piece in order to appreciate it completely. Here is a case where fluorescent light would probably cause the piece little or no ultraviolet damage but, because fluorescent light casts such weak and elusive shadows, it would be completely ineffectual in lighting the piece. For sculpted pieces and reliefs, shadows are instrumental in conveying the form.

Try to light a sculpted piece in a way that enhances its volume and form. Keep in mind that people must be able to move around a piece without suffering any glare or direct light spilling into their vision.

Each piece offers its own challenge, but, as a general rule, start off with a wash of strong even light from a single source. Then fill in from another source with a second wash that is about half or one third as strong. The aim is to cast light on more of the piece without destroying the shadows created by the initial source. The second bath can soften the shadows but should not obliterate them. Now, if you have the equipment, you might want to add in a little accent light in a dramatic manner. Keep in mind, though, its about sculpture, not your lighting skills.

Reliefs and even highly textured surfaces can be handled in a similar manner using a strong initial light source and filling in from another source with a secondary wash.

YOUR EXHIBITION AND SITE SPECIFIC NOTES AND MEASUREMENTS

YOUR EXHIBITION AND SITE SPECIFIC NOTES AND MEASUREMENTS

The Art of Displaying Art

CHAPTER SIX
LABELS, CAPTIONS & PRINTED INFORMATION

The appreciation and enjoyment of art are primarily visual, non-verbal experiences. A person viewing artwork is in a particular mind set that eschews the written word. In keeping with this mode, we can communicate certain information on a non-verbal level. We can direct peoples attention, move them along, speed them up, slow them down, all by non-verbal means. The arrangement of the work, the location of furniture, the placement of plants, the use of light, all subtly control us as we move about in a given area. We can even use graphic symbols to transmit information that, while communicating on a different level from the above mentioned, still do their job in non-verbal terms.

Symbols like a directional arrow or even a graphic of a cigarette with a red line through it tell us what to do or not to do on non-verbal terms. But, in certain situations, there is information to be communicated that is best transmitted in traditional literal terms.

Studies have shown that we first read the environment of a given area, second, we read the graphic symbols, and lastly, we actually read the printed word. We have to shift gears mentally from the strictly non-verbal world of color, light, shape and mass, into a different mode to read printed information.

This shift is a real issue in museum exhibition design. The relationship between verbal and non-verbal information, the kind of captioning, how much information, the tone of voice, and a label's design are all discussed endlessly by curators, designers, and directors, and there are no definitive answers in sight.

Fortunately, it is much simpler for you. In the home it is rare to label artwork. In the office and gallery, you often want to identify the work, but, the labels are traditionally concise and contain only the most pertinent information. At most they contain the artist's name, nationality

and date of birth, and the work's title. In the gallery, additional information regarding the medium, and statements like, *signed on the back, one of an edition of 10* or *not for sale*, (often NFS) are common.

There is no correct way to accomplish this, but there are some rules and guide lines to follow. The rules and guidelines will greatly help in communicating the information clearly and thereby making your presentation more successful. If you present the information in a manner that makes it immediately available and easy to grasp, the interruption to the viewer will be minimal and his experience less fatiguing.

First, let's consider typeface. The choice of type is somewhat subjective but, the kind of art on exhibition may suggest an appropriate font. Remember that legibility is the key and is of utmost importance — choose accordingly. I think you can occasionally mix two typefaces in one label for emphasis or clarity, but more than two leads to confusion and a busy, self-conscious label.

I think 18 point type is the smallest you should use and, when possible, I advise 24 point type. Statistics demonstrate that copy, set in all capital letters, slows our reading speed by almost 15%. This has little if any effect in a two or three word name or title, but it is something to keep in mind if larger blocks of copy are being used.

I like to remember the phrase, *I can see, perfectly!* when dealing with any kind of printed information. The four initial letters in the phrase, namely — I, C, S, and P help remind me of the four key elements that contribute to legibility.

I is for illumination. There has to be sufficient light on a label to read it easily. Ideally, the light should be at the same intensity as the light on the work it identifies. Time and energy spent adjusting to different light levels is wasted, and tired eyes contribute to short attention span and a quick exit.

C is for contrast. There has to be enough contrast between the letters and their background. We, of course, are most familiar with black letters on a white background. It's what we read every day in books,

magazines, and the newspaper. Black against white offers a very high contrast and a high degree of legibility as do bright yellow and black. Many highway warning signs are black symbols against a yellow field. This high contrast between letter and background makes the information easy to read. But, every day one runs into situations that are quite the opposite. My toaster oven, for example, has grey lettering and numerals against a slightly darker grey background and is virtually impossible for me to read. My stereo receiver, although not quite as bad, is a real struggle to understand because of a grey against black color scheme.

There must be enough contrast between letters and background for your label to be read easily. And remember the conditions under which it must be read. What is easy to read on your computer screen or drafting table might not be quite as legible in an exhibit situation. If you are designing the labels for an exhibit of southwestern jewelry and crafts, a turquoise letter on an adobe colored label stock might look just great, but, if the values of the two colors are too similar, the legibility is in jeopardy.

S is for size. I mentioned that 24 point is a workable size. The label should be readable from the same viewing distance as the artwork. Of course there are exceptions such as in the case of extremely large paintings when the labels would be the size of bus ads. When possible, it is wise to make your labels large enough so that people don't have to make many adjustments or unnecessary trips back and forth to read information. Keep in mind that more than half of the population over six years old wears glasses. We aren't always dealing with 20/20 vision!

In regard to the above three of the four elements contributing to legibility, you can overcome the shortage of one by increasing one or both of the other two. For example, if you are hopelessly in love with those turquoise letters against the adobe background, then, pick a larger typeface. Or, if your light level is low, you may have to forego

the nifty color scheme and select a rich, dark brown letter on a cream background. Keep in mind that the label must be legible yet unobtrusive.

Badly Placed Label

P stands for placement. I think that labels should be placed to the right of the work at a height of 50" to 54". I have chosen that height because it is comfortable for most viewers, even those in wheelchairs. Remember that many viewers wear bifocal glasses.

More important than left or right side, or 50" or 54" is consistency. Once you establish a convention in your presentation, try to stick to it.

The placement of labels is often an after thought, or left until the last minute. This is unfortunate and does a disservice to your exhibit. Try

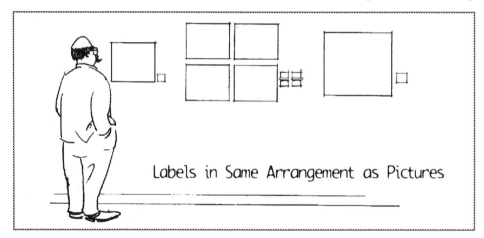

Labels in Same Arrangement as Pictures

to consider label location from the first stages of planning. Think of labels as part of the overall layout. If it is impossible to maneuver a label next to each work in a particular arrangement, the labels can be arranged in a corresponding configuration in an appropriate spot.

To maximize a labels legibility, it should be placed at a right angle to the viewer's line of sight. On the wall 50" to 54" off the floor does the job satisfactorily. When circumstances dictates that a particular label just can't be placed at this comfortable viewing height, which creates a convenient 90 degree angle with the viewer's sight line (e.g. because it is in a case or vitrine), try to angle the label by placing it against a little wedge of wood or on a tiny easel device fashioned from foam board or illustration board. In this manner, you can lean the label in such a way that the right angle is created or at least approached.

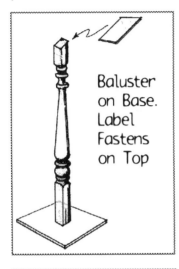

Baluster on Base. Label Fastens on Top

In the case of free standing objects, like sculpture or garments on mannequin, labels may be fastened to small stands to bring them high enough to read comfortably. At the same time the correct angle to the sight line can be created. I remember seeing an exhibition of Victorian garments where the labels were attached to ordinary stairway type balusters of Victorian design. The top of the baluster was cut on an angle, the label was glued on, and the baluster was fastened to a 6" x 6" square of plywood for stability. In another instance, a 4 foot strip of Plexiglass was shaped into a stand that held a card on one end. The other end was fastened to the floor.

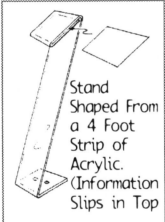

Stand Shaped From a 4 Foot Strip of Acrylic. (Information Slips in Top

If a piece in a showcase is viewed from more than one side, be sure to include a label on each side. People don't want to wait for someone to move aside so that they can read the only label. In addition, just one label in a case with several viewing sides sends a subtle message that the object has a front and back or that one view is better than another, which may not be accurate.

There are two more considerations concerning labels and text that are very important. First, don't over design your labels. The best labels will never call any attention to themselves. They should be unobtrusive. If people are talking about the labels after they leave your exhibition space, you did something wrong. Second, although the label placement should be considered from the beginning and be part of the layout, a label or any block of copy or information should not be considered as a design element, in the same sense that the work on exhibit is. Labels should remain supportive of, but subservient to, the artwork.

With today's technology there are countless ways to get information onto a sheet of paper. There is little need to move the label-making process outside the gallery. Even the most basic word processing program is capable of providing you with a dozen type faces in an almost unlimited number of sizes. Using colored paper or a color printer, the smallest gallery can produce museum quality labels.

Once your information is on paper, it is best to mount it onto a firm base. Foam board, illustration board, or mat board are more than adequate. There are some very handsome colored boards available; some have a white core or an interior that will show around the edge when the board is trimmed. Others are colored all the way through. If white edges on colored stock bothers you, use markers to color the edges.

If you have dry mounting capabilities available, use them to fasten the label paper to board. Another method is to use spray mount. If you have the copy for several labels on one sheet of paper, mount the whole sheet onto board first and then cut out each label.

Cut and trim the labels very carefully so that the edges are clean and square. Do this with a mat cutter, a mat knife, or an X-ACTO knife with a #11 blade. Always use a metal straight edge. Never cut against a plastic triangle or a three sided scale ruler.

Be certain to keep the metal straight edge on top of the label copy that you are cutting out to protect it from any slip of the blade. This

kind of cutting, especially if you are cutting labels mounted on foam board, will dull you blade in a remarkable hurry. And a dull blade is an invitation to disaster. It can quite easily slip and damage your work or worse. As soon as you feel that the blade is losing its edge and beginning to slow down, stop and change it. It is false economy to try and squeeze one or two more cuts out of a dull blade. When purchased in volume, blades are relatively inexpensive and are certainly less expensive than taking the time to reprint or a trip to the emergency room for stitches.

There are several methods of affixing the labels to the wall. They can be fastened with an adhesive or they can be tacked or pinned. A dab of glue will do the job but the label is often destroyed upon removal and there will be residual adhesive left on the wall. A small piece of double faced foam tape will work well, but it holds the label a slight distance off the wall — an effect you may or may not like. Foam tape also leaves an adhesive trace on the wall.

For many years, my favorite method of fastening labels was to tack them to the wall by toe-nailing a heavy duty dress maker's pin into the edge of each side of the label and then clipping the pin head off with a small pair of side cutters — technically, called diagonal cutting pliers. This works rather well but the pin shows just a little. Bank pins are sturdier than dress maker's pins and can be driven into the wall with less chance of bending, but they are quite difficult to snip off. After removal, there are only a couple of tiny holes left behind and, if you are careful, the label may be used again if necessary. There is a minor drawback in this procedure in that a slip or a miss with the tack hammer can leave a little dent in the label or wall.

The ingenious people at Benchmark (see RESOURCES) have come to the rescue again and offer a nifty pair of stainless steel pinning pliers and stainless steel headless pins of various sizes. These pinning pliers have a curved nose and a groove in the jaws. You place a pin in the groove of the jaws and, with a rolling motion of the hand and

wrist, one quickly develops the knack of rocking the pin through the label and into the wall. As a result, you avoid risky hammering and clipped pin heads rocketing around the room.

YOUR EXHIBITION AND SITE SPECIFIC NOTES AND MEASUREMENTS

YOUR EXHIBITION AND SITE SPECIFIC NOTES AND MEASUREMENTS

CHAPTER SEVEN
USING CASES, VITRINES & CABINETS

Paintings, for the most part, hang on the wall. Sculpture stands on the floor, or on a pedestal, or base that, in turn, stands on the floor. But, sometimes we want to present other types of objects or artifacts, that because of their size or other requirements, including security, require presentation in a showcase. Cases can be defined as transparent or partly transparent containers in which objects, artifacts, and information are placed. Cases serve to protect objects as well as elevating small objects to a comfortable viewing height. Cases can be attached to the wall or stand on the floor. Small cases can be placed on tables or on bases created especially for the purpose. A case can simply be a plain base on which a bottomless glass or plastic box is placed creating a vitrine. Strictly speaking, the bottomless box is the vitrine and the created combination is a vitrine case or vitrine cabinet.

When planning or designing a vitrine type enclosure, keep it relatively small. I remember all too clearly a time several years ago when a colleague and I took great care in placing many objects in a very complex display on a rather large base. As we proceeded to lift the vitrine over the intricate arrangement, it became embarrassingly clear that there wasn't enough head room to clear the top of the objects with the cover without hitting the ceiling. The whole display had to be removed and re-designed. If you want to use a tall vitrine be sure that you have ample ceiling height to accommodate twice the height of the vitrine cover above its base (see CHAPTER TWO - MAKING A MODEL).

You should have at least this much room and about a foot extra to allow yourself a little leeway and wiggle room. Even if you have kept your vitrine top short enough to fit easily over the arranged objects, be cautious and don't design or have built a box that is too broad or

Have Adequate Ceiling Height
Over Vitrenes

deep. An overly large cover when made of glass will become, by necessity, too heavy to handle comfortably. If made of plastic, the thickness of the top will have to be increased from the usual 1/4" up to 3/8" or even 1/2" to avoid the inevitable sagging that will develop. And, even a plastic box of larger dimensions will become too heavy. And, lastly, a base that is too wide and deep requires installers to lean dangerously far across the arranged items, and it creates too big a risk for the objects. Keep vitrines to a manageable, practical size.

In addition to the simple vitrine type of case, there are any number of styles and types of cases available in the display, exhibit, and museum field. A showcase can be a highly sophisticated device with its own mini-ecosystem of controlled temperature, humidity, light, and special atmosphere. Volumes could and have been written about showcases and hundreds of thousands of dollars can be spent.

Fortunately, for the most part, your showcase needs in the gallery, home, and office are considerably more modest. But, there are several things to consider and understand regarding cases. Basically, a vitrine should provide a safe place for objects while, at the same time, allowing them to be viewed easily.

First, let's consider the protection aspect. Various articles require different levels of protection from a host of assorted hazards. A certain degree of protection is offered by erecting a simple box-like configuration of glass or plastic panels around an object or group of objects

using KLEM fasteners. KLEMs are reusable panel connectors that allow you to build a box out of thin panels, which will have a slight gap between them. Small pieces can be boxed together on a table top or large 4 x 8 foot sheets of plastic can be arranged around a large but fragile sculpture. The connectors adjust to any angle from 90 degrees up to 270 degrees so that a large wall of panels can be created to zigzag along a large area. When used in an enclosed configuration, wooden bars can be fitted on top to further stabilize the construction. They will also provide a useful framework from which you can suspend fabric or light objects. This most simple of methods will protect against most accidental damage, touching, and theft. If you contrive to install a ceiling piece on top in the same manner, you will be able to keep out most dust. but it certainly isn't dust tight.

A myriad of case types and configuration is available from display houses. They can provide wall cases, floor cases, and table top items. Most companies have a wide inventory of ready-mades and, if need be, will be happy to adapt or custom design and build whatever you need. These cases can be equipped with built-in lighting.

The clear sections or windows of cases are either glass or plastic, such as *Lucite, LEXAN,* or *Plexiglass.* Of course, both plastic and glass are transparent, but they have several very distinct differences that you should consider before making a choice and specifying one or the other.

First, glass is hard and plastic is relatively soft. That makes the plastic case window very vulnerable to scratches. Carelessness or even incorrect cleaning can eventually result in a haze of scratches that are difficult to remove. But by the same token, glass, because it is less flexible and hard, is considerably more breakable.

Glass is much heavier than plastic. This makes a big difference when cases are being moved frequently or when an exhibit of pictures glazed with glass has to be shipped by air.

Glass is difficult to work with, whereas plastic is relatively easy. Straight cuts are no real problem in either glass or plastic but, when cutting an oval, circle, or any kind of curve, plastic, while no picnic, is vastly easier to cut than glass.

Glass is cheaper than plastic, which might matter in some cases, but is probably negligible over the long run.

And, lastly, plastic has that irksome quality of collecting phenomenal amounts of dust on its surface. There are anti-static cleansers and sprays available, but plastic still seems to remain a dust magnet.

These features and peculiarities are not intrinsically good or bad, but they should be considered when a choice is to be made. The features of one should be weighed against the other.

Note that when utilizing glass or plastic, it is most helpful to identify the material in some inconspicuous spot on the case. Similarly, a glazed picture should indicate on the back whether it is glass or plastic. The reason is that glass and plastic are handled in different ways and cleaned with different solutions. Glass gets taped up to travel, for instance, whereas taping plastic is a big mistake.

Another function of a vitrine, which is less obvious but no less important, is its control over the stability of relative humidity. The climatic conditions inside a case can be adjusted in two ways. The first is referred to as an active system and involves a highly refined and sophisticated set up of humidifying, dehumidifying, and air conditioning devices. Cases equipped in this fashion contain extremely valuable and irreplaceable items and are found in the Library of Congress, certain historical museums, and the museums. They are far too complex, intricate and expensive for general use.

For most of our needs, a simple enclosed case that keeps its contents safe and clean is all you require. Yet in certain situations, when you want more stability than a simple closed case offers, you can gain a little more control over the climate inside a showcase by employing a passive method of humidity control. That method takes advantage of

the humidity buffering qualities of materials, like silica gel, to slow down any changes in relative humidity. The harm done to encased objects by minor fluctuations in the temperature and humidity within the case is largely a result of the action of the change and not necessarily a reaction to the extent or range of that fluctuation. So, the more gradual we can make any change the less harmful it becomes. Hiding some buffering material in a case tempers any change and eases the stress to the object in question. And, in most instances, the resultant lower humidity is indeed desirable.

A few words of warning about the placement of cases — reflected light and reflected images can ruin a perfectly well presented exhibition. Glass and plastic surfaces must be positioned so that there are no annoying reflections in the viewer's line of sight. Avoid placing a low case directly under an overhead light or directly in front of a window. Do not place a tall case or any large glazed piece directly opposite a window. Don't place two tall cases opposite each other, especially if one or both contain interior lighting. And remember to light reflective surfaces from an angle steep enough so that viewers don't see their own reflections in the glass.

Fortunately, most art objects are quite happy at a temperature and humidity range that we find comfortable ourselves. That is — a relative humidity of 50% plus or minus 5%, and a temperature of 65 degrees Fahrenheit plus or minus 5 degrees. A couple of notable exceptions are Japanese lacquered objects that require a higher humidity level and parchment, paper, and fabrics which require a humidity level 5 to 10% lower. Every effort should be made to maintain this range.

When that is simply impossible, you should strive to keep the humidity at no less than 40% in winter and no more than 60% in the summer. The temperature can drop to 55 in winter and rise to 80 in summer. Remember the key. When radical changes are unavoidable you must endeavor to control the rate of change so that it will take

place as gradually as possible. The conditions change in a gallery, office, or home whenever a door is opened to the outside or a group of people passes by. The temperature goes up and down with each door opening and the humidity changes with each breath. Obviously, these situations cannot be avoided and it would be absurd to try to control them. But the results of these changes can be dealt with quite successfully if we place our most vulnerable items inside a case. In the same way that a violin case allows a musician to carry his delicate instrument from his 70 degree apartment building to the corner curb side on a 20 degree evening, hop into the back seat of an 85 degree taxi, out again at Lincoln Center, another 20 degree walk to the stage door, then into a 65 degree concert hall with no damage to the violin, a vitrine offers similar protection to your art.

YOUR EXHIBITION AND SITE SPECIFIC NOTES AND MEASUREMENTS

YOUR EXHIBITION AND SITE SPECIFIC NOTES AND MEASUREMENTS

CHAPTER EIGHT
CONSERVATION CONCERNS

In order to feel secure about putting artwork and other artifacts on display, we have to be aware of the elements in our environment that may be potentially damaging to the particular type of material that we intend to exhibit. There is virtually no way to keep a piece free from some kind of eventual deterioration. A curator once noted that every oil painting starts to die the second the artist lifts his brush from the canvas.

By being aware, however, of why and how work deteriorates, you can make an effort to keep changes in paintings, graphics, photographs, and other art objects to an absolute and probably undetectable minimum.

Objects removed from ancient tombs exhibit very little change from the day of their burial until the day of their discovery, only to disintegrate rapidly in our modern environment. There is a basic lesson here. Most curators will point out that the conditions in the tomb were just about perfect for many items, where as modern exhibit conditions are quite the opposite. The most important condition that the tomb offers is absolute and total darkness.

Remember, light, especially sunlight, is a major cause of deterioration in most art objects with the most susceptible being natural textiles with natural dyes. Watercolors, photographs, and most other works on paper suffer severely from exposure to sunlight (see CHAPTER FIVE - LIGHTING WORKS OF ART).

Another major factor in the tomb conditions is the relatively low humidity. With the important exception of Japanese lacquer and some furniture, most objects and paintings like low humidity. In addition the air in sealed tombs was free of dust and any chemical pollutants, and in most cases, there were no vermin or other destructive pests making

meals of the artifacts. Furthermore, in many tombs the temperature was just about perfect. But, of utmost importance is the fact that tomb conditions were constant. Darkness, combined with a consistency and stability of conditions allows many objects to last indefinitely.

If certain curators had their way, all objects of any significance would be continually closed up under these self -same conditions for eternity. And its not hard to follow their reasoning. Fortunately, even the strictest of curators understands that we want to view their and our art and share it with others. If you follow the guidelines set forth in this book and observe the basic rules when exhibiting your artwork, you will be able to share it with others for education, study, and sheer joy while doing little, if any, harm to the work.

There are two particularly dangerous windows of vulnerability in the exhibition of artwork. The first is the movement and handling of each piece as it goes from place A to place B on the wall and back again. And the second is a somewhat different kind of hazard, namely the exposure of the work to exhibit conditions during its stay on the wall. In both instances, the risks can be greatly reduced through intelligent handling and placement, and careful control and management of the environment.

Most accidents happen when work is being moved; so, move objects as little as possible. Its infinitely safer and easier to move paper cut outs around your model (see CHAPTER TWO - EFFECTIVE USE OF A MODEL).

The dangers of light have been previously covered, but problem areas in our everyday environment still exist, albeit to less serious degrees. You must deal with those problems in your home, office, and gallery. They are — temperature, relative humidity, and air pollution. Fortunately, in most cases the human comfort level is reasonable for most mixed collections. 50% relative humidity with a fluctuation of plus or minus 5% is fine. For fabrics or works on paper, the lower end of this range is preferable, and of course, the less fluctuation the better.

Ideally a temperature of 65 degrees [plus or minus 5 degrees] is your goal for most pieces. If this is too difficult to maintain, the plus/minus range may be widened to +/- 10 degrees. Always keep in mind, though, that it is the fluctuations of temperature and relative humidity that do the most damage. So, in addition to trying to maintain conditions as close to the ideals as possible, make every effort to keep changes and fluctuations minor and gradual. More vulnerable pieces can be placed inside closed cases, which will greatly increase the stability of the conditions immediately around them.

Works on paper should be properly framed. Framing serves to isolate and stabilize each piece. Frames also help to protect your art from dust and insects.

YOUR EXHIBITION AND SITE SPECIFIC NOTES AND MEASUREMENTS

YOUR EXHIBITION AND SITE SPECIFIC NOTES AND MEASUREMENTS

CHAPTER IX
ALTERING AND MANAGING SPACE

Whether you are hanging a painting or two in the living room, squeezing another vice president's glowering gaze onto the board room wall, or hanging the art department's best in the high school gym or cafeteria for a week or two, there are some basics that will result in a more effective display. Matching the correct quantity of the right work to the space available is important. Often the size, shape, and amount of work are predetermined. In such a case, the space for it must be adjusted to suit the requirements of the work.

All situations will present their own particular problems, but the two that occur most frequently are the extremes of too little space or too much space. When the room in which you have to work is t big, either too large an area or perhaps endowed with a ceiling that is 16 or 18 feet high, you will want to bring the focus of the room down to a more serviceable scale. The space should be made more intimate and appropriate for the amount of work being installed. One inexpensive and useful way to scale down a large room, particularly one with high ceilings, is to install paneling on the existing walls, create new walls out of similar panels, and hang the work in this new space.

In many cases, 4 x 8 foot sheets of Homosote covered with fabric will serve nicely. The simplest and least expensive treatment is to cover the Homosote with felt and fasten the panels to the wall horizontally. For a temporary exhibit of smaller light weight pieces, this will work extremely well. The choice of color plus type of fabric can enhance your exhibit, and at the same time, bring the focus of attention down to the scale of the work.

Our field of vision is such that, at a comfortable viewing distance, a four foot wide horizontal band will, for all intents and purposes, fill up our view. There is really no need to invest time, trouble, and money into giving a tall room a complete makeover, when the area that really counts is at our eye level.

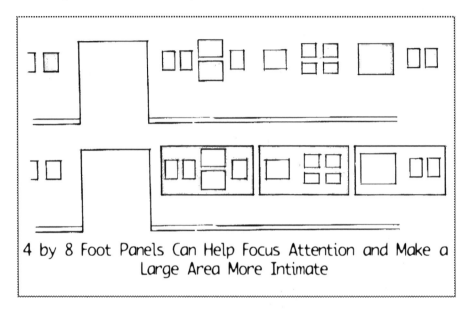

4 by 8 Foot Panels Can Help Focus Attention and Make a Large Area More Intimate

4 x 8 foot panels are a useful basic size and proportion for several reasons. First, and most importantly, they are the manufactured size, and you don't have to do any large scale cutting when they arrive from the lumber yard. In fact, all sheet goods, from which you might be inclined to make panels, come in a 4 x 8 foot configuration. So you can begin with an inventory of standard sized panels that will become modular panels for a variety of uses in you space.

Felt, as well as most fabrics, comes 54" width, so that it is easy to cover a 4 foot by 8 foot panel with one piece of goods without having to fasten two pieces together. In addition, there is little or no waste.

I initially mentioned Homosote panels covered with felt because its the cheapest and easiest way to go. There are several variations and refinements that can enhance the over all presentation of your exhib-

The Art of Displaying Art

Metal Hanging Cleat

Place Panel on Top of Fabric

it. First, there is the choice of the surface of wall panels. If fabric isn't appropriate, the panels can simply be sheets of birch plywood that have been painted or stained. This will give a more commercial, high-tech look to the space. The panels can be fastened directly to the wall with the appropriate hardware. Any holes showing or remaining after the exhibition is dismantled can be filled and painted. Sometimes a decorative piece of hardware can be used to cover visible mounting hardware during the exhibition. Benchmark (see RESOURCES) sells an aluminum hanging cleat that is just the ticket for the safe and secure hanging of panels and even cases. The cleats fasten to the wall and to the back of the panel or piece and there are no holes or hardware showing on the front.

If you plan to hang work that is of significant value or heavy, or work that will remain up for an extended period of time, a simple Homosote panel may not be sufficiently substantial. You may have to back it with a sheet of plywood. This affords a much more secure backing for the hanging of work. Light work and any captions or labels may be fastened to the Homosote alone, but the heavier work should hang from hardware that extends through the Homosote into the wood.

The choice of fabric can vary widely. Velvet or velour will create an elegant surface whereas a traditional early American print might be just the thing for an exhibit of folk art or early American primitives.

The best way to cover a panel is to place it face down on a piece of fabric that has been pre-cut to extend 3 or 4 inches beyond the panel

Metal Hanging Cleats on Piece and on Wall

all the way around. Starting in the middle of one of the long sides, begin fastening the fabric to the back of the panel by pulling it snug and stapling it. First, put in 3 or 4 staples at 3" intervals along the first side. Next, go across to the middle of the opposite side and repeat the procedure — pull snug, then, a few staples at 3" intervals. Now, go to one end and do the same thing, next, to the center of the opposite end. If you have pulled the fabric snugly and evenly, you should have a diamond shape on the fabric when you raise the panel and peek. Now, continue to add staples at the same 3" intervals, working out in both directions from the center of each side. Proceed in the same order as you began — first a long side, then, the opposite, then, the short sides and so on. Add several staples each time and continue to alternate until finished. Make nice neat corners. You may have to trim away some excess, especially if you used a thick fabric.

These fabric covered panels can be backframed or box framed. The frames will give them greater stability and a finished look. Backframing generally means applying a flat framework of 1" x 3"

Back Frame

Box Frame

around the edge of the panel on the reverse side. That procedure gives the panel additional stability and makes it appear somewhat thicker. It can be done either before or after the panel has been covered with fabric, with slightly different results.

The Art of Displaying Art

There are two methods of box framing. The first is quite similar to the back framing method explained earlier, except that the 1" x 3" stock is on its edge when it is run around the rear perimeter of the panel. This will give the impression that the panel is considerably thicker. The second method of box framing is to fasten a 1" x 3" frame work to the rear of the panel as just mentioned but to apply it 4" to 6" in from the edge. This will create the illusion that the panel is floating a few inches off the wall. Generally, in this case, the back frame is painted flat black. Either way, the work can be securely hung by using the aluminum cleats from Benchmark.

You can create a similar effect by running a couple of lengths of wood through a table saw at a 45 degree angle. Fasten one piece to the wall and the other to the back of the panel. This will give the panel all the support it needs and hold it tight against the wall. Be sure to think carefully when you attach the cleats to the panel and to the wall. Its easier than you might think to get them mixed up, and you'll feel pretty frustrated sliding the two cleats off each other while you wonder why the panel won't stay put.

Table Saw at
45 degree angle

Cleats

Hung horizontally, these panels will help create an exhibition atmosphere. Sometimes it's nice to introduce a 4 foot by 4 foot panel now and then to relieve monotony and create a little rhythm.

4 foot by 8 foot panels are a useful size and shape in a vertical orientation as well. If a 4 foot wide horizontal band isn't high enough for the work you

Cleats on Wall
and Piece

are hanging, the panels can be installed upright and rest on the floor. This way larger work will have enough room and not appear to hang off the bottom of the panels.

These same 4 foot by 8 foot panels can be configured into 3 or 4 sided kiosks, when you need to create more hanging space in a room. They can also be fastened together to make a temporary wall or to change or reduce the space in a room that is too big. Covered sheets of Homosote can be installed on the other side too, so that a two-sided wall can be created.

Don't worry that the panels are only 8 feet tall while the room might have a 12 or 15 foot ceiling. People don't like to look much higher than 7 or 8 feet. Looking up tires your neck muscles. If the walls have work on them and the work is well lit, people will be quite happy to look at the work only. Time, effort, and money spent creating a wall treatment above this height are wasted.

If you don't have the facilities to build these panels or to do this type of back framing, remember you can fasten sheets of covered Homosote or plywood directly to the walls.

Another method of creating kiosks or temporary walls is to fasten hollow core doors together. Sometimes you can get a good deal on doors that are damaged on one side. Doors don't come 8 feet tall, but they are tall enough for most purposes. If you start collecting an inventory of doors, and have the storage room, you can reuse them in various configurations.

One useful technique is to install large screw eyes in the edges of each door in a consistent pattern, so that you can mix and match and link them to each other with a bolt and wing nut. Before you put a wall in place, you can apply a strip of double-faced foam tape to the

Screw Eye Pattern in Panels or Hollow Doors

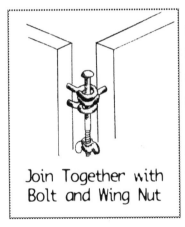

Join Together with Bolt and Wing Nut

bottom. It is surprising how secure this type of panel can be made with a little tape. They become remarkably resistant to shearing or any bumping pressure from the side. Double-faced foam tape is one of the most useful products you can have in your tool box for affixing labels, steadying frames, and securing small items in a case. Be warned that foam tape is both sticky and toxic! Keep it away from archival material.

One of the major considerations in the exhibition of artwork, in virtually any venue, is that your viewer or visitor feels at ease. This is an easy task in your home because the atmosphere is congenial and relaxed, and the creature comforts are many. But in a gallery, and to a lessor extent, in a office complex, the conditions are not quite the same.

One of the most immediate problems to solve in order to make your visitors feel secure and comfortable is to clearly designate which areas of the space are open to them and which are not. This concept is very important. If your viewer feels at all uneasy, you are doing your exhibit a disservice. The concept of space allotment is critical and must be carefully considered and differentiated clearly.

For the sake of discussion, lets divide your space into three categories called public space, exhibit space, and administrative space. In your home the term public space may seem oddly inappropriate, but I think the basic concept is still valid and applies there too. Public

space is the area where visitors are welcome. It is the area in a gallery where people move freely without special permission or invitation. In an office complex, it is the waiting areas and lobbies. At home, it would probably be the foyer, living room, and dining room. In some cases, it might include a den or study. It probably does not include your bedroom or the attic.

Exhibit space is where the art is hung or otherwise exhibited. In a painting gallery, this may one or more spaces with walls. In a gallery, which exhibits sculpture or any dimensional objects, for example a crafts gallery or shop, for example, it would include shelves, platforms, pedestals, counters, tables, cases, or any place where artwork or object is displayed. In the office or home, it is the walls of the areas designated above as public space plus any tables or cases devoted to displaying work.

Administrative space is the area where tasks are performed. The staff is there when not on the floor of the gallery. Administrative space may simply be a storage or stock area. In any case, the visiting public is not welcome in administrative without an invitation. It is your back stage area. In an office situation, it would be the private offices and work rooms. At home, it might be the laundry or utility room, rooms like pantries, and in most cases, bed rooms.

After dividing your space into these categories, I can't stress enough how important it is to make these delineations clear to all. People don't want to trespass into areas that are off limits to them. The hesitancy and insecurity, that is created when the designation is not clear, contributes to a lack of confidence in your viewers and begins to erode their feeling of well being. You will lose them. They probably will not depart but they will check out mentally. This is a subtle thing, but we are governed by subtle things.

The delineation of these spaces can be accomplished in a number of ways, that can range from a closed door with a sign reading Keep Out to a change in light quality or a different floor covering. We don't

go behind the counter in a department store or delicatessen, nor do we go behind the desk in a reception area of an office complex. And we wouldn't wander into someone's bedroom and walk into their closet with out some kind of invitation. Somehow the message is made clear that it is not our space to visit.

Observe and identify what indicators give us the message and use that information when organizing space. In very temporary conditions or in situations that change frequently, such as a movie lobby or a bank, when it is not possible or practical to develop a subtle guidance system, ropes and stanchions do the job.

Remember, when planning an exhibition, that there will be times when several people will be in your space. Be certain you provide enough space for them to move about with ease. Two people can squeeze by each other in a rather narrow aisle space, but consider that someone may be bending over studying an object in a showcase and the passerby may be portly. Allow adequate room. There are plenty of charts and even entire books available about human dimensions and space needs, but careful observation of people, common sense, and a tape measure will provide all the information that you require for planning and execution.

Planning and hanging an exhibition is hard work but, when you have finished, your visual reward is immediate!

YOUR EXHIBITION AND SITE SPECIFIC NOTES AND MEASUREMENTS

YOUR EXHIBITION AND SITE SPECIFIC NOTES AND MEASUREMENTS

YOUR EXHIBITION AND SITE SPECIFIC NOTES AND MEASUREMENTS

BIBLIOGRAPHY

Applebaum, Barbara. *Guide to Environmental Protection of Collections.* Madison, Connecticut: Sound View Press, 1991.

Boylan, Bernard R. *The Lighting Primer.* Ames, Iowa: Iowa State University Press, 1987.

Ellis, Margaret Holben. *The Care of Prints and Drawings.* Nashville, Tenn: The American Association for State and Local History, 1987.

Guldbeck, Per E. *The Care of Antiques and Historical Collections.* Nashville, Tenn: The American Association for State and Local History, 1985.

Keck, Caroline K. *How to Take Care of Your Paintings.* New York, New York: Charles Scribner's Sons, 1978.

Keefe, Laurence E. and Inch, Dennis *The Life of A Photograph.* Boston, Massachusetts: Focal Press, 1984.

Klein, Larry. *Exhibits, Planning and Design.* New York, New York: Madison Square Press, 1986.

Korn, Jerry. *Caring for Photographs.* New York, New York: Time-Life Books, 1972.

Neal, Arminta. *Exhibits for the Small Museum.* Nashville, Tenn: American Association for State and Local History, 1976.

_____. *Help for the Small Museum.* Boulder, Co: Pruett Publishing Co, 1969.

Reeve, James K. *The Art of Showing Art.* New York, New York: The Consultant Press,Ltd., 1986.

Spencer, Otha C. *A Guide to the Enhancement & Presentation of Photographs.* Englewood Cliffs, New Jersey: Prentice Hall, Inc, 1983.

Tufte, Edward R. *Envisioning Information.* Cheshire, Connecticut: Graphics Press 1990.

Velarde, Giles. *Designing Exhibitions.* New York, New York: Whitney Library of Design, 1989.

Vergo, Peter. ed. *The New Museology.* London, England: Reaktion Books, Ltd., 1986.

Wilhelm, Henry. *The Permanence and Care of Color Photographs.* Grinnell, Iowa: Preservation Publishing Company, 1993.

Witteborg, Lothar P. *Good Show! A practical Guide for Temporary Exhibitions.* Washington, D.C: The Smithsonian Institution, 1981.

RESOURCES

ARMEL CO.
P.O. Box CL
Norton, MA 02766
800-637-3720

ART & FRAME SUPPLY INC.
165 W. 2700 South
Salt Lake City, UT 84115
800-456-3901

BENCHMARK
P.O. Box 214
Rosemont, NJ 08556
609-397-1131

IMPEX SYSTEMS GROUP, INC.
2801 N.W. Third Ave.
Miami, FL 33127-3921
800-933-0163

M & M DISTRIBUTORS
P.O. Box 189, Route 522
Tennent, NJ 07763-0189
800-526-2302

S & W FRAMING SUPPLIES INC.
40 Smith St.
Farmingdale, NY 11735
800-645-3399

TALAS
568 Broadway
New York, NY 10012
212-219-0770

UNITED MFRS. SUPPLIES
80 Gordon Dr.
Syosset, NY 11791
800-645-7260

INDEX

A

B

C

I

illumination, 61, 64, 67, 74
illustration board, 77-78
incandescent, 60-61, 64
individual integrity, 20
insects, 97
integrate art, 10
intervals of blank space, 12
intrinsic impetus, 18

J

jewelry, 35, 38, 63, 75

K

kiosk, 64

L

label, 73-80
lamps, 60-61
landscape, 16
large paintings 9, 36, 75
large stone, 38
level, 8, 12, 16-17, 27, 61, 64, 67, 73, 75, 89, 96, 104
LEXAN, 87
light, 11, 14, 27-28, 37, 45, 47- 48, 51, 59-68, 73-75,
86-87, 89, 95-96, 103, 105, 110
lighting design, 59
lighting equipment, 36
low humidity, 95
LUCITE, 87

M

manuscripts, 60-62
marble tops, 39
masking tape, 28
mat knife, 27-28, 78
metal, 27, 38, 48-50, 63, 67, 78
metal foil, 67
metal screening, 67
metal sculpture, 38
mollys, 47
move, 9, 13, 15-17, 29, 35-38, 52, 60, 66, 68, 73, 77-78,
96, 110-111
museum, 7-8, 10, 18, 29, 64, 73, 78, 86

U

V

W